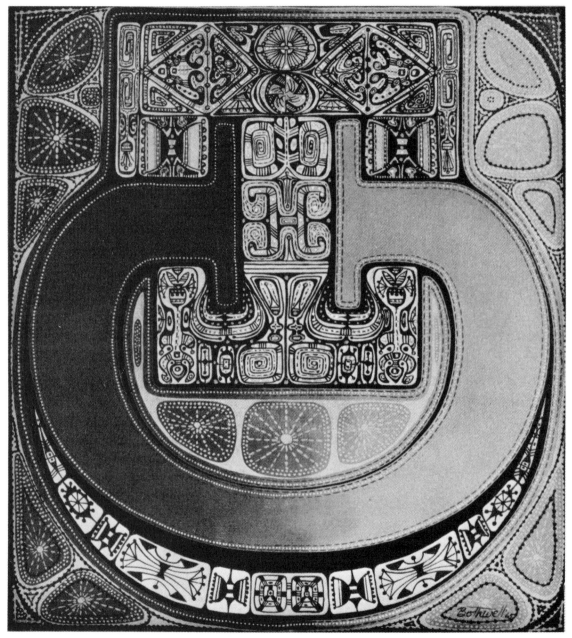

Inner Meaning of the Letters of the Alphabet: Letter T, by Dorr Bothwell, 1965. Acrylic on canvas (32 by 36 inches).

NOTAN

THE DARK-LIGHT PRINCIPLE OF DESIGN

DORR BOTHWELL AND MARLYS MAYFIELD

DOVER PUBLICATIONS, INC.
New York

This book is dedicated to my beloved teacher, Rudolph Schaeffer,
who introduced me to the magic of color and the principles of Notan.

—Dorr Bothwell

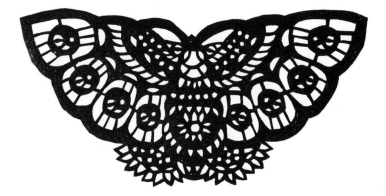

1 Butterfly. Chinese Paper cutout. Orange paper flecked with gold. From
Shen-Si Province.

Copyright © 1968 by Litton Educational Publishing, Inc.
All rights reserved under Pan American and International Copyright Conventions.

Published in Canada by General Publishing Company, Ltd., 30 Lesmill Road, Don
Mills, Toronto, Ontario.
Published in the United Kingdom by Constable and Company, Ltd., 3 The
Lanchesters, 162–164 Fulham Palace Road, London W6 9ER.

This Dover edition, first published in 1991, is an unabridged republication of the
work originally published by Reinhold Book Corporation, New York, in 1968.

Manufactured in the United States of America
Dover Publications, Inc., 31 East 2nd Street, Mineola, N.Y. 11501

Library of Congress Cataloging-in-Publication Data

Bothwell, Dorr.
 Notan : the dark-light principle of design / Dorr Bothwell and Marlys Mayfield.
 p. cm.
 Reprint. Originally published: New York : Reinhold Book Corp., 1968.
 ISBN 0-486-26856-X (pbk.)
 1. Design. 2. Composition (Art). I. Mayfield, Marlys. II. Title.
NK1510.B67 1991
745.4—dc20 91–16975
 CIP

CONTENTS

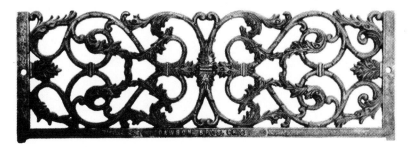

2 Fireplace grate front. Cast iron made in Chicago around 1884.

FOREWORD

We put thirty spokes together and call it a wheel;
But it is on the space where there is nothing that
 the utility of the wheel depends.
We turn clay to make a vessel;
But it is on the space where there is nothing that
 the utility of the vessel depends.
We pierce doors and windows to make a house;
 and it is on these spaces where there is nothing that
 the utility of the house depends.
Therefore, just as we take advantage of what is, we should
 recognize the utility of what is not.

—Lao Tse (Translated by Arthur Waley in *The Way
and Its Power*. (Houghton Mifflin Co., Boston, 1935.)

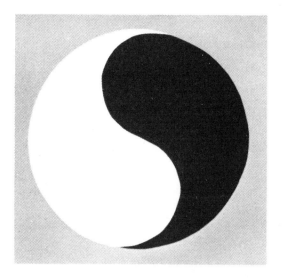

3 Yang and Yin. Ancient symbol of dual forces held in unity. The Yang represents the active or masculine, the Yin the passive or feminine. The sigmoid line bisecting the circle represents the movement or play of forces around the unchanging center. (It is one of the oldest and most universally distributed symbols.)

This poem, attributed to Lao Tse, was written about two thousand years ago in China. It is a poem about Notan, the basis of all design. Before Notan or the meaning of this poem can be understood, it must be experienced. And the experience of Notan is what this book is all about.

Notan is a Japanese word meaning dark-light. The word, however, means more than that. The principle of Notan as used here must be further defined as the *interaction* between positive (light) and negative (dark) space.

The idea of this interaction in Notan is embodied in the ancient Eastern symbol of the Yang and the Yin, which consists of mirror images, one white and one black, revolving around a point of equilibrium. Here the positive and negative areas together make a whole created through a unity of opposites that have equal and inseparable reality. In the Yang and the Yin symbol, as in Notan, opposites *complement*, they do not conflict. Neither seeks to negate or dominate the other, only to relate in harmony. It is the interaction of the light and the dark, therefore, that is most essential.

An explanation of this profound symbol represents special problems for most of us because, although we acknowledge in our sciences that both male and female cells must unite in order to create life, that both a positive and a negative charge are needed to produce electricity, we still must struggle with the implications of the Yang and the Yin as universal law. The Western culture thinks in terms of *opposed* dualities and attaches the moral values of good to the positive, of bad to the negative. Or we seize upon the positive as the only reality and dismiss the negative as invisible and nonexistent.

To understand Notan, therefore, requires a special effort on our part; it demands a totally new orientation to *seeing*. Nevertheless, the effort is well worth the while if it enables us to see Notan—the basis of all good design—as it exists all around us.

The concern of this book is with Notan's practical applications to design. It accomplishes this purpose through a series of six problems of progressive difficulty intended to direct the art student as well as the practicing artist toward a new way of seeing that will eventually enable him to experience Notan directly for himself. Only through such a process can the student learn to perceive Notan and apply it to his own work. The six controlled problems presented here are designed to lead the student progressively and inductively toward that experience. At the end of this series of problems, the student will be able to identify Notan both as a concept and as an experience. And, too, he will be able to conceive and manipulate Notan in his own designs.

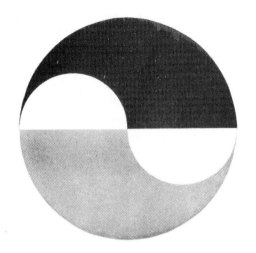

4 A variation of the Yang-Yin symbolizing the horizon with the sun rising and setting.

These Notan problems have been devised, tested, and revised by Dorr Bothwell over a period of twenty years. She first began to develop them at the California School of Fine Arts while teaching a course in basic design. Many of the problems came in response to requests of other instructors to give their students a more thorough understanding of the function of negative space, in order to prepare them better for work in such courses as lettering or graphic design.

This book is the first to appear devoted solely to the topic of Notan. Most design texts, if they discuss the problem of dark-light at all, usually dismiss it in a rush to get on to an encyclopedic coverage of all aspects of design.

Beside offering the student a treatment in depth of a basic art principle, another consideration in the planning of these problems was that of reducing the variables to assure the student's success. Too often the art student is offered a bewildering array of materials and techniques. Instead of finding the discipline he wants and needs, he is often told, "Be creative," or "Do what you want to do." There can be so many variables in any one assignment that the student finds to his disappointment that he has no objective measure of his achievement. He can never be sure what he has learned or where and how he has succeeded.

The problems in this book are designed to offer that objective measure to the student. Each one must be mastered before he can advance to the next. All of the problems have controlled variables, yet all allow for the satisfaction of individual solutions. The number of skills necessary has been reduced to the ability to use scissors and paste; technically, the problems could be completed by children. Every effort has been made to state and to illustrate them clearly enough to enable the student to teach himself with this text. The student must work inductively in order to find his solutions—he must experience, not just conceptualize—so that he will be able to apply Notan to his own work. This skill is particularly important since Notan is a design principle so basic that it should be mastered for work and study in *every* field of art, whether it is painting or photography, sculpture or mosaics, textiles or pottery, jewelry or printmaking, architecture or interior decoration.

Notan is the basis of all design.

—Marlys Mayfield

1 NOTAN IN EVERYDAY LIFE

Notan appears in useful objects such as tools in both a primitive culture as well as in a modern technology. In the latter case, however, the Notan produced is more often a by-product of utility. Scissors (Fig. 79) for instance, have beautiful Notan because they must be designed with spaces to fit the fingers; keys must have holes for chains (Fig. 15), and razor blades must fit into the razor (Fig. 8). The negative space exists in these cases because of the requirements of utility, but is not necessarily an intrinsic element of the design.

Many of the examples of Notan illustrated in this book are taken from folk art. Indeed, the instinctive use of Notan in folk or "primitive" art is an almost invariable characteristic. The intuitive or folk artist, unlike the formally trained designer in modern society, does not have to be taught to remember the negative or to see it in balance with the positive. He has not been taught to seek to dominate nature or to conquer it; on the contrary, he feels himself a part of nature, and his work reflects that sense of balance.

The primitive and the modern artist also differ in their approach to decoration. In modern technology decoration is often only added as though it were an afterthought to attract the buyer's eye. It can often be an unessential feature and in no way united with the form. The Pueblo Indian craftsman, however, who decided to decorate the simple dish with a bird (Fig. 13) was very much concerned with the integration of form and decoration. Working within the confines of the shape of the plate, he succeeded in designing a bird that would become an inseparable part of the whole or a design in which the spaces around the bird would assume a form with an exchange of positive and negative. In good design like this, the only right solution is one which finds such a union of decoration and form. And when this is discovered, the negative space will no longer be "empty," but, instead, there will be Notan.

The primitive artist also differs from the sophisticated artist in his use of symbolic decoration. In the United States symbolic decoration has practically disappeared except in religious objects and in Pennsylvania Dutch hex signs. Yet the first impulse of the primitive artist is to use symbols. Because

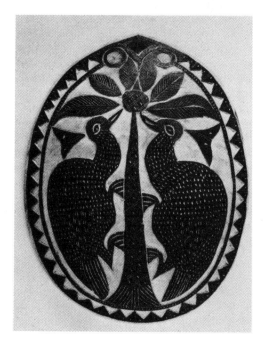

5 Carved and dyed calabash from Oyo, western Nigeria. Although the composition is symmetrical and fixed, the birds seem to be climbing because of the movement implicit in the negative shapes between their feet and the tree.

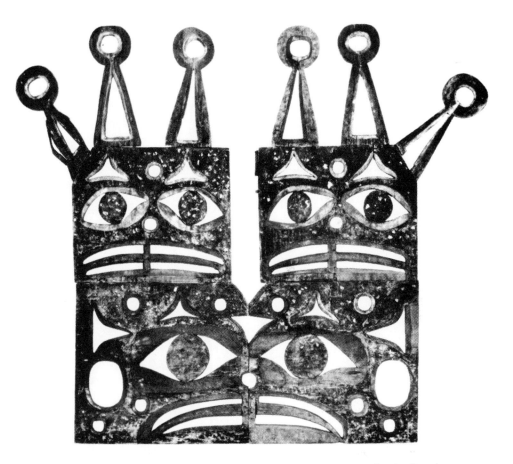

6 Kwakiutl Mechanical Screen. This screen was used in a ceremony in which a female war dancer returned from the woods possessed by the mythical and changeable sisiutl spirit. The screen's design represents the human face, which is always in the middle of the sisiutl with its two serpent heads at either end. The screen, made to rise from a pit in the house in which the ceremony was held, was struck by the dancer with her sword, causing the two halves to split apart and seemingly disappear. Collected by Samuel A. Barrett in 1916. Wood, traces of mica, black, white, and red paint. Height 61 inches, including projecting horns. Lent by the Milwaukee Public Museum. (18060) Photograph courtesy of Dr. Albert B. Elsasser, co-author with Dr. Michael J. Harner of *Art of the Northwest Coast.*

symbolism dictates further restrictions in both the decoration and the form of the object, the resulting design often involves a very good exchange of negative-positive.

An excellent example of this achievement may be seen in the Kwakiutl mechanical screen (Fig. 6). The "distortions" and the Notan here resulted from the creation of a design within the restrictions of the materials and the ritual use of the screen. It had to be made of wood sturdy enough to stand, and it had to incorporate a slot together with hinges so that it would open and fall when struck by the sword. Yet the triumph of the screen is that the "distortions" or modifications not only brought about the stark dramatic contrasts of the Notan, but also the accomplishment of the artist's main purpose: the creation of a work of great dramatic and ritualistic power.

7 Stove "cooling" shelf. These shelves extended to the right of the cooking surface. Many manufacturers took advantage of the space to show the initials of the company (center) and the name of the stove model. Made around 1890. The Notan here was the result of necessity.

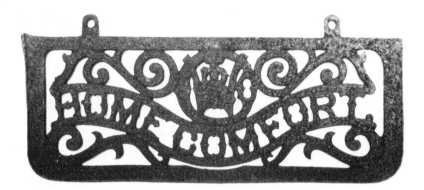

8 Though the openings of these razor blades are utilitarian, when seen as Notan they become decorative units working with the white negative spaces to form an interesting pattern.

9 Circus number. This large (36 by 24 inch) lithographed number was printed around 1890. In those days circus posters were put up well in advance without dates. The exact date, such as this three, was pasted on when the show reached an adjoining town. The negative spaces were carefully designed to make the number readable at a great distance.

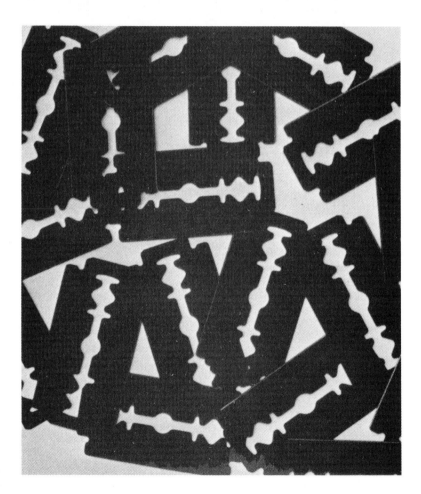

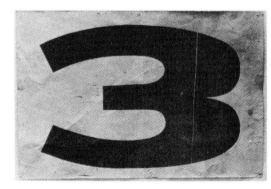

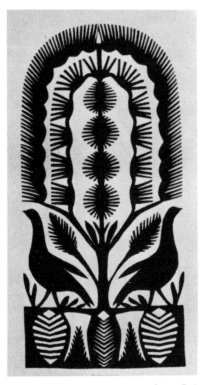

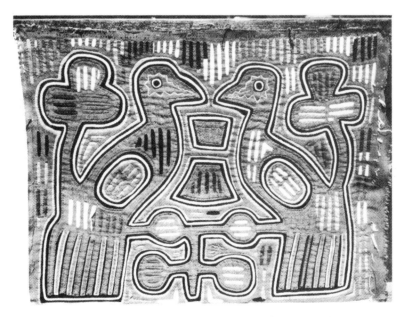

12 Applique stitchery, San Blas Indian work, Panama. A beautiful integration of birds, plant, and the spaces surrounding them.

10 A symmetrical paper cutout from Poland with fine interplay between the negative spaces. A good example of instinctive Notan.

11 Stove shelf made around 1900 showing "Art Nouveau" influence. Here the heaving scroll dominates, and the negative spaces are monotonously uniform in size and shape.

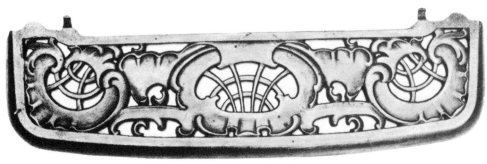

13 Clay dish. Pueblo Indian work, Acoma, New Mexico. The symmetry of this design is relieved by the turn of the bird's head. The distribution of the pattern is dictated by symbolic meaning.

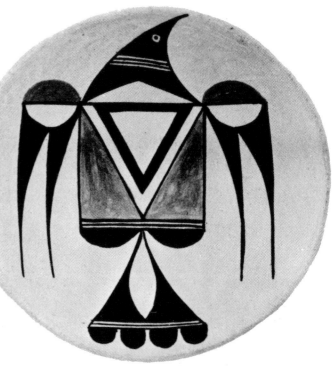

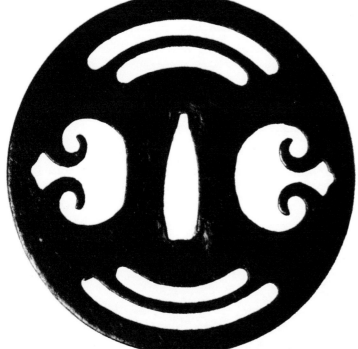

14 Sword guard of wrought iron. Japanese, circa 1800. This nineteenth century Japanese sword guard is ornamented by negative space—for the iron is decorated only by its symmetrically arranged openings. M. H. De Young Memorial Museum, San Francisco, California.

The problems imposed by the limitations or restrictions of materials also serve to distinguish the trained modern artist from the primitive one; and again this endeavor relates to the development of Notan. The folk or primitive artist finds himself bound by a narrow range of materials and has little choice but to work within the limitations of his medium. However, since his attitude is such that he does not feel impelled to conquer nature, he is able to work *with* nature; indeed, he employs the restrictions of his materials to discover his design.

The African decorator of the calabash (Fig. 5) made a simple design that is definitely integrated with the oval shape of the calabash. Nothing is hidden—the rim of the wood is exposed; it is easy to see the basic material. The same may be said of the Pueblo plate; the decoration was not intended to camouflage the plate.

In America before the technical revolution, the designer's major concern was that of overcoming the deficiencies of his materials. There was the design problem, for instance, of the "cooling" shelf on the cast-iron stoves so popular in the nineteenth century. Since the cooking was done in a cast-iron kettle on a wood or coal stove where the fire could not be reduced rapidly, it was necessary to move the kettle to a cooling shelf that permitted the circulation of air; the holes designed for this purpose led to the creation of Notan in a design made as beautiful as possible in the style of an age of fanciful decor. But the designer's purpose was to hold together the holes of the stove shelf.

A similar problem faced the designers of the Japanese sword guards of a much earlier period. Iron was used because of its ritual significance, but in order to preserve the balance of the sword, it was necessary to subtract weight from the material. This necessity was again met by cutting holes—but the Notan resulted from the search for symbolic designs. Between the requirements of ritual and the limitations of the material, Notan was created.

The designer in a technology faces few limitations in his choice of materials or tools; he has any number of choices to make and he often makes poor ones. His is the dilemma of

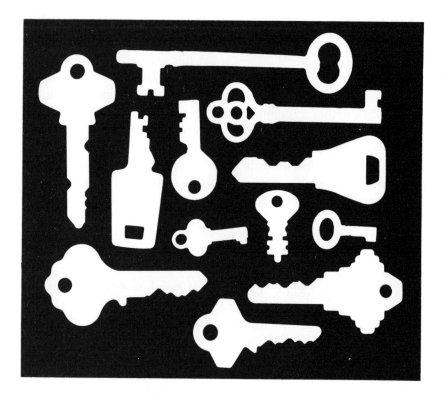

15 The holes in the keys set up a visual rhythm with the varied spaces in between the keys and the keys themselves. This rhythmic interplay is the basis of Notan.

freedom; it sometimes produces wonderful things, but also sometimes the grotesque. And because the skills of the modern designer are not as challenged as they would be by greater restrictions, he must more consciously seek to produce Notan.

In order to challenge and to discipline the skills of the modern design student, the problem-solving approach used in this text has set up restrictions that imitate the working situation of the primitive artist. These restrictions appear as limitations of materials (the use of only black and gray construction paper, a white format, scissors and glue) and in the design problems (i.e., "Within a given format, arrange five circular shapes having a sequence of size to produce asymmetrical balance").

Because the solving of these problems involves discipline and results in a sense of achievement, the student should, at the conclusion of this course of work, approach his own future design problems with an entirely new method and spirit. Al-

though all the problems presented here are two-dimensional, the implications for three-dimensional design should become apparent. Moreover, no matter what field of art the student enters, or is presently engaged in, he will, at the completion of this course of work, approach his problems first and last for Notan.

The artist working in photography, painting, or printmaking will no longer continue to see the background as mere support for his subject, but will realize that the background can be as dramatic as the subject. He will be forced to a new awareness of what before was considered to have no particular meaning or vitality. His idea of the relationships in his work will also be changed, and the result will be a new unity.

If he is a sculptor, he will become as interested in the shapes of open spaces as in those of solid areas; he will also seek their interaction in a unified statement. Many sculptors have utilized this knowledge in their work, the most prominent example being Henry Moore. (See Figs. 34 and 38.)

The weaver who studies Notan will begin to understand that he has been struggling with positive and negative relationships in his work all along. A closely woven tapestry can depict a two-dimensional design—abstract or figurative—which can be developed with a painter's understanding of Notan. Much traditional pattern weaving is based on the control of positive and negative reversals, stunning examples of which appear in Peruvian work. Structural weaving must also depend on an understanding and control of negative space. A stole, for instance, made in lino or gauze weave consists of twisted warp threads held together by the weft in sufficient tension to create negative diamond or lozenge spaces. In three-dimensional weaving also—from Indian baskets to modern woven sculptures—the forms are governed by their containment of the negative.

For the artist working in stitchery, appliqué, or quilting, a mastery of Notan is equally important. Many traditional American quilt patterns, as well as the bold Hawaiian ones, are based on positive and negative reversals. In the traditional patterns, Notan will appear through the contrasts in arrangements of the

geometrical or figurative units. In the Hawaiian quilt the Notan is created from the contrast of two layers of cloth; one brightly colored cloth, almost the size of the quilt, is folded and cut away (paper-doll or snowflake style) to create a design in one piece, which, when appliquéd to the white quilt, will create an interacting design. The San Blas Indian appliqué employs this principle in an even more complex arrangement (see Fig. 12) in which many cloths of different colors are layered together. Here the design is created from the negative spaces or from the holes or slits cut through to bare the different layers of cloth beneath.

The jeweler should also become more conscious of the relationship of positive and negative space in creating his design. A ring or a bracelet must be sculptured to contain negative space. In decoration the jeweler might also consider employing Notan in metal openwork or in the contrasts of stone and metal.

For the interior decorator, the "traffic pattern" might be called the negative space which must be considered when designing furniture arrangements. The proportion and scale of the furniture, furthermore, must relate to all the remaining negative dimensions of the room, from the height of the ceiling to the views from the windows.

Finally, in mosaics or collages, an understanding of Notan will prevent the artist from becoming lost in the segments of shape and color of each piece of glass, pebble, or paper. Since he must remain physically close to the composition and compose constantly as he works, it is especially important that he learn to see his design as a whole and from afar. Notan will enable him to retain sufficient control to achieve a work whose negative and positive spaces will emerge or submerge at the will of his purpose.

An understanding of Notan traditionally has been and will be a requirement for mastery of any field of art. It enables the artist to compose a work in which all the parts relate to create a unity of visual organization, impression, or pattern. Notan enables the artist to achieve a Gestalt—or more simply, to create a *design*.

2 SYMMETRICAL AND ASYMMETRICAL BALANCE

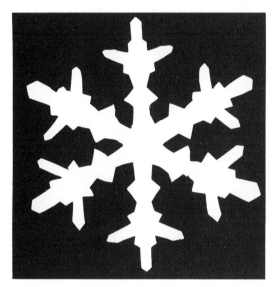

16 The snowflake is a good example of radial symmetry.

17 The butterfly exemplifies bilateral symmetry. The wings and their decorative patterns repeat exactly on each side of a fixed axis.

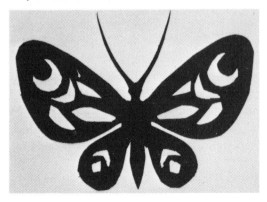

Our first objective in this problem is to achieve asymmetrical balance.

Balance is a universal property of all things. Many words are needed to explain balance as an abstract concept, but it is actually based on a feeling that we all understand and acquire—even before we speak. Indeed, we cannot stand or walk until we learn to feel balance.

In nature there are two kinds of balance: the symmetrical and the asymmetrical. Symmetrical balance always proceeds from a central point and is based on the principle of scales or the seesaw. Forms symmetrically arranged work on the vertical, horizontal, or diagonal axis, all extending from this central point of balance. The emphasis or weight is repeated equally and appears fixed or static to the eye, giving a feeling of stability and certainty. It is a design that can be easily seen and understood as well as rationally or mathematically devised (Figs. 16 and 18). The Polish cutout (Fig. 10) is a symmetrical design arranged in balance along the vertical axis.

Symmetrical balance may be bilateral or radial. One of the many examples of bilateral symmetrical balance is the butterfly: an identical pattern is repeated on either side of two halves of a median line (Fig. 17). The human body is also bilaterally symmetrical. Radial symmetry is exemplified by the snowflake (Fig. 16) where there is an exact repetition of any number of parts radiating from a fixed center. Among the innumerable examples of radial symmetry in nature are the starfish and the daisy.

Asymmetrical balance is not always logical nor easy to perceive (Fig. 19). The perception and creation of this kind of balance are based on feeling rather than reason; to be right, it must "feel" right. We feel it in our own movements—particularly in the shifting of our weight that occurs in dance. It is dynamic and more free than symmetrical balance because it is based on movement and continuous shifting of weights or accents. In all the arts asymmetrical balance is a great basic principle. In painting it involves complex balances and contrasts of hues and textures; however, in this book we will only be concerned with a balance of black and white.

18 Dissimilar shapes and weights seem to balance when placed in a symmetrical and static relationship.

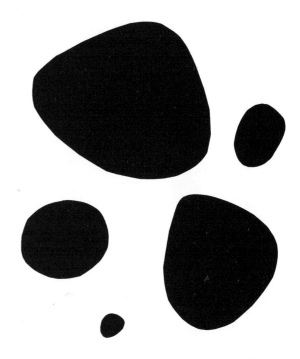

19 The asymmetrical arrangement shifts weights over and around the center without resting on it, giving a feeling of movement. Forms suggested by pebbles eroded and shaped by water are easily felt as weight.

SELECTING SHAPES

In this problem you will be working with the arrangement of five shapes cut from black construction paper. In devising your shapes to achieve asymmetrical balance, think of forms that have no noticeable direction or movement but that convey a sense of *weight*. The sense of weight in shape can be added or subtracted through our associations; the difference in weight does not lie in the forms themselves. In Figures 20 and 21 the weight is added or subtracted through the use of slight modifications that transform abstract shapes into representational symbols. The addition of a stem and leaf gives us the solidity of an apple. The wiggly line, on the other hand, suggests the weightlessness of a drifting balloon.

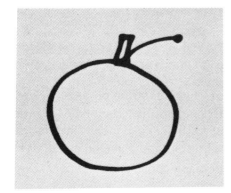

20 We give weight to a simple form when a fruit is suggested by the addition of a stem.

21 A shape seems to be light enough to float when the addition of a string makes us think we are looking at a balloon. We add or subtract weight according to the ideas we associate with a shape.

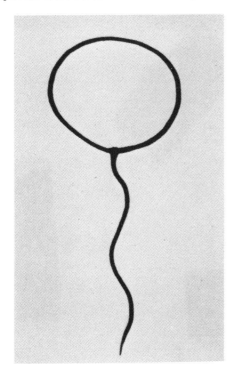

SHAPES TO AVOID IN THIS PROBLEM

1. A shape that pinches (Fig. 22).
2. A shape too busy because of fast contours.
3. Triangles which create directional movement (Fig. 23).
4. Rectangles whose direction repeats or opposes the format (Fig. 24). (Shapes that parallel the format make tracks and lock the viewer's eyes into a corner.)
5. Static diagonal arrangement of forms whose weight we cannot grasp. Here the shapes balance asymmetrically, but they have too much movement. (Fig. 25)

SUITABLE SHAPES

What shapes then are suitable? The best way to discover this is to begin with the shapes of the things you love. For instance, you might be one of those people who come back from walks with pockets full of pebbles—water-smoothed brook or beach pebbles. Concentrate on these shapes when cutting your forms. Other forms might be suggested by fruit: the shape of a pear, a peach, or a plum. Not all pears are as obvious in shape as a Bartlett pear; you might think of the subtle silhouette of the D'Anjou pear. After you have a sensation of the bulk of the form, look at the edge of the shape. Follow the edge with your eye, don't just give it a rapid glance. You will see that some curves seem to move very fast, turn a sharp corner, then slow and straighten out. Pick up some water-eroded pebbles and study their curves. Become conscious of the movement suggested by the edge or contour of the form.

Do not hurry with this exercise. Like plants and trees, we create at the same rate that we grow—very slowly. Though we are always trying to force ourselves to rush at the rate of machines, our pace in this work *cannot* be rushed. Also, do not *strive* for originality; your originality comes from being truly yourself. If you consciously try to be different, you will be someone else and no longer original. Just be yourself and trust your intuition.

Complete the composition in Part I before going on to the next section.

PART I

Assignment Create a design that is asymmetrically balanced.

Materials One sheet of white construction paper, 12 by 18 inches. On this paper rule a rectangle (or format) 10 by 12 inches, leaving 2 inches at the top, 4 inches at the bottom, and one inch on either side.

One sheet of black construction paper, 12 by 18 inches.

Scissors and paste.

22 Shapes that look as if they could pinch or hurt us are difficult to feel as weight. Wiggly shapes are so active we cannot estimate weight.

23 This problem seems to balance asymmetrically only because the pointed triangular shapes set up a movement around the center, keeping our eye too busy to estimate the weight of the forms.

24 Parallel lines are easily paired by the eye. They act like tracks and fix a form in place. Rectangles tangent to the sides of the format create opposition. Weight is negated by this movement.

25 Here the black shapes are arranged on either side of an imaginary diagonal which runs through the center from top right to lower left. The spacing remains too much the same between all the smaller spots and the larger ones. The whole is split in half with no tension to unite the two halves.

Working Procedure

1. Cut out of the black paper five shapes in a sequence of sizes, i.e., one large, one very small, and three sizes in between.
2. Arrange these five shapes or weights within the given format to create a shift in attention from one area to another. Your objective is to create asymmetrical balance.

<div align="center">PART II</div>

In the composition just completed you concentrated on the problem of balancing asymmetrically five positive shapes or weights to create a shift of attention from one area to another.

The next exercise in connection with this problem is a visual one. (NOTE: In the classroom or at home all completed student work should be tacked to a board that allows a viewing distance. This will permit all work to be studied with a new perspective; at the same time, a critique and discussion of all work should be conducted by the instructor.)

1. Pin your work (or the compositions of a whole class) to a board and give yourself a viewing distance of at least eight feet.
2. Now consider the black shapes no longer as *weights* or things, but as HOLES—or NO-THINGS. You might imagine, for instance, that you are looking at a piece of solid white wood full of empty black holes. This visual exchange—the perception of a shift from things to no-things, from no-things to things—is characteristic of Notan.

At this point you will probably want to alter your composition. The white area may look far too vast and uninteresting.

<div align="center">PART III</div>

1. The third visual exercise is to look once more from the same distance at the composition.
2. This time think of your work as a representation no longer of HOLES but of BLACK ROCKS in WHITE WATER.
3. If and when this representation is realized, both the negative and positive spaces will no longer alternate in their

26 The two largest areas are placed on diagonals in such a way that a line almost runs through their centers, keeping them in a static position. The opposite diagonal is suggested by the two smaller spots. If the white space is thought of as water flowing around rocks, we do get a better feeling of balance.

27 Here the eye is pulled around in a triangular movement, giving a sensation of balance. The smallest dot also generates much interest.

existence but will interact in an interchangeable balance. The rocks and the water will become equally important, equally real. *This is the creation of Notan.*

If the black shapes in your work (now seen as rocks) were placed too close together or to the edge of the format, you will find that the negative space (the water) appears unable to flow. When this happens, the tension created by this constriction in the design locks both the design and the eye of the viewer in one area, and the shifting balance of the whole is lost. If you have avoided all these pitfalls, and if you find *both* your positive and negative spaces have achieved dynamic identities, then your work will have Notan.

In the third visual exercise Notan came into being when both the positive *and* negative areas began to exist as realities in balance. When the black weights or holes on a static surface became rocks and water seen as equal entities, then Notan was achieved. Notan was found when the spaces between the forms became one unified form flowing like a mountain stream around and between the rocks or positive shapes, sealing the whole design into an organic whole.

This experience is at the basis of the culture of the Japanese *bonseki* garden, such as the Ryoanji in Kyoto, where the sand is raked and appears to flow like water around the rocks. In our problem we have given these black forms the idea of weight, considering them as pebbles. By giving them the sensation of weight, we also gave them stability; and when this happens, the negative space is released to flow in a pattern between the rocks and holds the entire composition together in dynamic balance. The rocks are held in a fluid pattern which they themselves create! After we observe how the space between the forms seem to move, we notice that the forms themselves seem to shift very slightly, and suddenly the format becomes the only fixed frame of reference. Again the Japanese *bonseki* gardens achieve exactly such an interchange of elements and utilize these wonderful principles of the interplay between the solid and the fluid. The solid and the fluid are universal polarities, and there will always be enjoyment for man in their interchange.

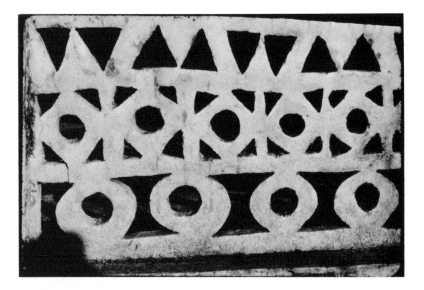

28 Decorative railing, Oyo, Western Nigeria. These mud-cement walls are made first; then the openings are cut out while they are still wet. The variation of repeat in the triangles at the top is unusual.

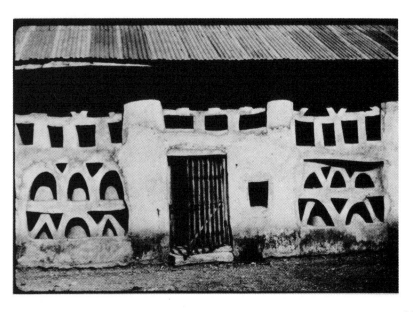

29 Mud-walled house, Northern Nigeria. The mud domes in the bottom openings keep the animals in and intruders out, and vary the fascinating effect of the facade. The carved and notched bars of the door create good Notan.

30 In this rectangle which has been expanded asymmetrically, a counterpoint is set up between straight and curved forms, giving a pleasing sense of balance.

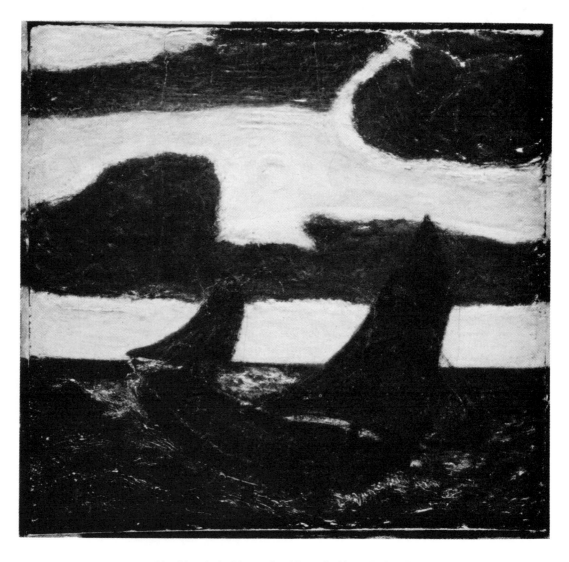

31 *Moonlight Marine* by Albert Pinkham Ryder. The Metropolitan Museum of Art, Samuel D. Lee Fund, 1934. The exchange between the moonlit sky and the ominous dark clouds rocks the eye back and forth, forcing us to feel the movement of the sea-swung ship below.

32 *The Vases* by Ozenfant, 1925. © 1968, The Museum of Modern Art (Bliss Bequest), New York. After the overlapping play of the vase shapes the background begins to appear not as space but as angular and curvilinear areas pressing in on the central forms.

33 *Mountain, Table, Anchors, Navel* by Jean Arp, 1925. © 1968, The Museum of Modern Art, New York. The anchors and table that seem so strong and insistent are, in reality, apertures cut in the painted cardboard to show the white board behind them.

34 *Head* by David Smith, 1938. Cast iron and steel. Although the cast iron and steel forms fix the features and mass of the head, it is the negative space which gives the flexible volumes to the cheeks.

35 *Africa* by Robert Motherwell, 1965. Acrylic on canvas. The Baltimore Museum of Art. In this painting, black and white exchange importance in a rhythmic thrust and swing.

36 *Epitaphs* by Jack Youngerman. Created for the "Painters and Poets" feature of the No. 5, 1965, issue of *Art in America* magazine. The dark-light of fluttering robes and moon-reflecting water restates Ezra Pound's poem in visual terms: "Fu I/ Fu I loved the high cloud and the hill/Alas, he died of alcohol.

"Li Po/And Li Po also died drunk./He tried to embrace a moon/In the Yellow River."

37 *Red on Blue Field* by Lorser Feitelson, 1967. Acrylic on canvas. Collection of the artist. Tension and movement always attract the eye first. Then the moving space changes to become the impersonal space between opposing forms or pressures.

38 *Presence* by Adaline Kent, 1947. Magnesite sculpture. San Francisco Museum of Art, San Francisco, California. Gift of the Women's Board and the Activities Board. The space pulled in and enclosed forms a counterpoint with the cast stone itself.

3 NEGATIVE SHAPES WITH POSITIVE REVERSALS

39 A square has been expanded to suggest a cross radiating from the center. In spite of the horizontal movement of the long bars, the original square shape is still insistent.

40 This expanded square seems light and gay. The central diamond shape with extended heart shapes is a nice contrast to the sharp pointed triangles.

EXPANSION OF THE SQUARE

This problem is sometimes described as an expansion square. The mechanics of the assignment can best be u stood by studying two student examples of symmetrical designs. Each cutout of the design taken from the dark paper is folded outward (or reversed) and pasted on the white paper along the base of its negative shape. The piece cut out remains in contact with its former space. The first example (Fig. 39) is made from a square of black paper. On its sides semicircular shapes were folded out (or back) so that they remained in contact with the original square, and then were pasted down. Next, long narrow strips were cut out on either side of these semicircles and pasted to the base of each cut. Now, since the long negative space left by these cuts appeared too empty, triangles were cut and folded inward on either side of the narrow opening left by the strip. Then semicircles were cut into the unbroken edges of the top and bottom of the square. However, the design still seemed too heavy. To open it further toward the center, pointed cuts were made; and the resulting form, which resembles a triangle with a curved base, was folded back and outward.

Asymmetrical designs may be seen in the examples of student work in Figures 30 and 41. The shapes cut on one side of these compositions are not repeated on the other side; nevertheless, balance is achieved.

Asymmetrical balance is seen most clearly in Figure 30, where the rectangle has been expanded into a shape very much longer than it is wide. A small figure-eight pattern which appears at the upper left is repeated in larger proportions below and further elaborated with a sort of teardrop that finishes the design.

Figure 41 is a decorative arrangement suggesting fruit and flowers in the sun. The cut-out corner in the lower right disfigures somewhat the order of the square. However, the feeling is consistent throughout the design, and it is aesthetically pleasing.

41 A very unusual expansion of a square. The basic symmetrical shape is kept with an asymmetrical arrangement of recognizable elements. The design only holds together because of the sharp nervous style of execution.

OBJECTIVES

The objective behind the utter parsimony in this problem is to make it impossible to cut a positive shape and ignore its negative twin. If the positive shape you cut is clumsy, its negative space will be clumsy also, but neither can be discarded. Moreover, if the cuts are not repeated symmetrically, the choice of an asymmetrical cut will require a search for asymmetrical balance.

The second objective of this exercise is to begin to engage you in the kind of thinking process you will always find necessary to create Notan, a process which might be called "a dichotomy of attention."

Assignment Create from the square by expansion a design of positive and negative twin shapes that reflect one another.

Materials One sheet of white construction paper, 12 by 18 inches.

One sheet of construction paper in black or a color of a dark value. Cut from this a 6-inch square.

Scissors and paste.

Working Procedure

1. Try a symmetrical pattern first, repeating one of your patterns vertically and the second pattern (perhaps a variation of the first) horizontally.

2. Do not cut into the corners of your square, but maintain the order of its shape.

3. If you are uncertain how to proceed in planning your design, consider the following steps:
 a. Establish a movement.
 b. Find a pattern that you like and repeat it.
 c. Let one element predominate.
 d. Consider secondary movements, accents.
 e. Then watch what is left over.

4 CONTROL OF POSITIVE AND NEGATIVE SPACE

42 The white design seen in this illustration is the negative space created by the black patterned strips which are positive. The white catches our attention first because the forms are convex. The black, although positive, is concave.

THE CONTROL OF TENSION IN DESIGN

In the composition just completed we were not concerned with tension because the spacing was arbitrarily restricted and not subject to judgment: the positive was always hinged to the negative as a reflection.

In this assignment we will return again to the problem of the interdependency of spacing, tension, and balance, a problem which we discovered through trial and error in the first assignment. There our first objective was to avoid tension that might stop the free play of our asymmetrical balance. Uncontrolled tension, it was suggested, could be caused by the creation of pinching or threatening shapes and by placement of the shapes too close to each other or to the edge of the format. In both cases, the attention of the viewer would have been arrested at isolated points, and the balance of the negative and positive lost for the whole composition.

TENSION CAUSED BY SHAPES AND THEIR PLACEMENT

The selection of shapes that threaten or endanger was given only cursory attention in the first chaper because of our primary concern with weight. An understanding of such factors is nevertheless important in design where we must manipulate visual interest and understand how and to what extent it can be influenced in terms of tension. The greatest degree of visual interest and tension is caused by a threatening shape. The suggestion of threat is inherent in sharp nicks and spears, points and crosses, and will be noticed immediately, either consciously or subconsciously. Pointed fingers, arrows, hooks, thorns, horns, and pincers are other warnings of danger. We also fear collisions, a possibility that the eye detects at once when a shape opposes the edge or corner of the format.

Anything that looks as if it represented an eye alerts us. As an experiment you might paint a dot on a beach pebble and drop it on a pile of other pebbles. The one with the dot will stand out and seem to look at you. Try to feel the tension caused by all such shapes. If we use them unthinkingly, we will lose control of the flow of the design.

43 Tension is created by opposition. In this case a curved surface bulges toward the straight line blocking its path. A still stronger feeling of tension is between the arrow and the perpendicular line.

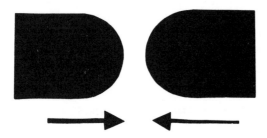

44 Equal masses pressing towards each other force the space to flow around them. This kind of relationship we sense as tension. The opposition between the two arrows is easily felt.

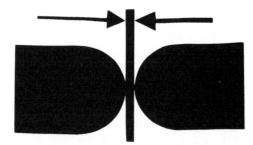

45 When these forms touched the straight line, the sense of tension was lost. Although the rounded part of the shape is fixed to the straight line, they seem to be trying to move away from it. The arrows, however, seem to have their points embedded in the line.

Whether we are conscious of it or not, we all have emotional and sometimes tactile associations with convex shapes. We associate roundness with the vitality of the sun, the mystery of the moon. Tactually, a round shape suggests such pleasant things as oranges and apples or the rubber balls and round playthings of our childhood.

The concave has less pleasant associations. Decaying things collapse inwards, the convex becomes concave with age. Sometimes two unpleasant or threatening shapes will create a convex negative space, and when this happens the degree of visual interest is very high (see Fig. 56).

CONTROLLING TENSIONS IN ARRANGEMENT

To return again to our first problem, our chief concern with tension at that time was related to the arrangement of shapes in asymmetrical balance. The starting point in the placement of the shapes was a consideration of their relationship to the fixed center. Although the shapes could not rest directly upon it, as they do in symmetrical balance, their attraction to this center was the magnetic source of tension for the whole arrangement. A second source of tension that made this composition possible was the opposition of the lines of movement in the shapes to the static lines of the format. It was exactly this juxtaposition that created for us the negative entity that was finally realized.

Before beginning this third assignment, let us review in simple diagrams more precisely what was happening—what we were manipulating—in that first problem.

The three illustrations here (Figs. 43-45) demonstrate the three kinds of relationships established in our first problem. The first is the opposition between a straight line and a curve. The second illustration shows opposition between two equally matched, curved surfaces which are moving toward each other. In the third example, the arrangement is fixed and static. The curves are fixed against the horizontal line, all tension is lost, and no negative design is produced.

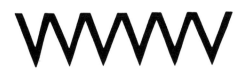

46 When pressure is applied to both ends of a straight line, it buckles up into a zigzag.

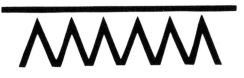

47 A straight line above the zigzag forces us to feel the up and down movement of the line.

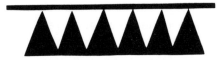

48 When the bottom part of the zigzag is filled in, it becomes a series of black triangles reaching up. When a line is placed above these points, we suddenly see a series of white triangles or pennants reaching down. This exchange is Notan.

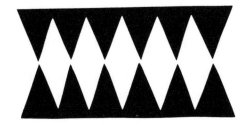

49 We can see this design several ways: a series of white diamonds, sides touching, or black saw teeth about to mesh. But if we see the bottom triangles as reflections of the upper, we immediately sense a white horizontal line running between their points.

Like the curve, the zigzag (Fig. 46) is also a basic line of movement, or one of the simplest forms of repetition. In the second diagram (Fig. 47), a straight line is placed above the zigzag, causing the points of the zigzag to push toward the line, creating for the first time tension and opposition. Now the white does not flow into a formless background. Nevertheless, in this example we see no shape—only the contrast between a zigzag line and a straight one. We fix our minds on the directional quality of the lines without having any sense of existing space.

In Figure 48 the line is lowered to touch the points of the triangles. The white negative spaces now have become entities, and we can give them a label, seeing them as a series of white triangles or as pennants hanging suspended from a black line. In addition, the lower triangles (now filled in with black) can also assume a label such as "black mountains." And as the eye focuses on the black mountains, the white pennants are lost, or they become, in their turn, negative space. But when the eye seeks the pennants again, the black mountains disappear, assuming in turn their negative role.

In Figure 49 we repeat or reverse our black triangles to face one another. The result is the creation of what might be considered a line of white diamonds, or two rows of triangles facing each other, or a new independent form, or two fused reflections with an implicit white horizon between them.

SPACING, MOVEMENT, AND TENSION

In the third problem we are going to learn how to control the *movement* of positive and negative space. We experienced this feeling of movement when we shifted our attention from the black mountains to the white pennants (Fig. 48). We had to un-see the black mountains before we could see the white pennants.

In this assignment the movement will not be between similar shapes such as the black and white diamonds. Instead, we will design a series of identical ornamental black strips which, when separated, will form white strips of a completely different design.

50 This design is actually made up of black strips, but when placed close together, the effect is of three decorative white strips on a black background.

51 The black strips here are identical with those used in the illustration above, only now they have been placed so far apart that they seem isolated against a white background.

52 The spacing of the black strips depends upon making the white spaces equally strong and decorative so that, if we wish, we can see them as positive pattern.

PROPER TENSION IN SPACING

In considering our negative forms, we will be concerned first of all with the achievement of proper tension in our spacing. In this first illustration (Fig. 50) the black strips were placed too close together, giving the effect of a white design on a black background. The black loses all character and only the white has form.

On the other hand, when the positive shapes are spread far apart (Fig. 51), no tension can form between the positive and negative: the effect is decorative black strips against a white background.

If the decorative black strips are placed in relation to one another so that the white spaces in between become equally decorative (Fig. 52), with a shift of our attention these white strips seem to be as carefully designed as the black strips. This produces what we call an *exchange* between the black and the white because they now have equal interest or reality. This alternation of reality (exchange) is possible because a balance between the positive and negative shapes has been accomplished. They have begun to complement rather than to dominate one another, their movement is controlled, and Notan has been achieved.

CRITERIA FOR NOTAN

As we discuss the problems of tension, balance, and movement in design, we shall use a number of terms designating characteristics which might be called criteria for Notan, as follows:

1. Notan occurs when the negative space is sufficiently enclosed by the format to produce a shape that the eye and mind can grasp. (Notice the pennants and black mountains in Figure 48.)

In a design for commercial wrapping paper from a Tokyo bookstore (Fig. 53) we easily identify a shape—a centaur. The negative design surrounding this shape, however, cannot be labeled. It remains abstract, secondary, a background—no-

溝ノ口駅前

53 Centaur design from Japanese wrapping paper. Notice how the drawing of the figure pulls in and pushes out the space surrounding it so that the figure and background are one.

thing and supposedly non-real. Though the artist has not made the background as important aesthetically as the figure, he has given it enough importance so that it can be regarded as part of the whole. If we turn the design upside down, the centaur is lost and we see two abstract designs with a better balance between the positive and negative shapes.

2. A second characteristic of Notan is its reversibility. Look again at the two centaurs. On the right the black and the white values are reversed without producing any change in the balance or configuration of the design.

Now note the potential reversibility of positive and negative space in the photograph of a net as opposed to rows of papers (Figs. 54 and 55). If the papers were white surrounded by black space or the lines of the net black against white space, the design features would remain unchanged.

54 In this net the white lines or cord are the positive or "real" while the black spaces are the negative or "unreal."

55 Here a kind of net pattern is made of the negative white spaces between black paper rectangles, the reverse of the net above.

3. A third characteristic of Notan is that the shapes in the design have an exchange value. At the command of the artist and the viewer, the design should be capable of moving from dominance of the positive to dominance of the negative. One should be able to say, "Let the black come forward, let the white stay back;" or, "Let the white come forward, and the black stay back." Neither image should dominate on its own initiative, as it would without proper balance and tension. (Look at Figures 50-52.)

OBJECTIVES OF THIS ASSIGNMENT

Here you will seek to create Notan through the realization of negative and positive configurations in an equal exchange. Here the word "configurations" is used because what we want to plan and cut will not be a *representation* of an object but rather what is known as a "pure" design. Two stylized Christmas trees or profiles, for instance, would not necessarily create good negative space. Subject matter is not our starting point: here we are manipulating form to fit principles of positive and negative space. If we start with a representational form, we have to be strong enough to destroy or modify enough of its identifying characteristics to create design.

Assignment Design and arrange three identical patterns in sufficient tension with one another to create three negative shapes that have an exchange value with the positive shapes.

Materials One sheet of white construction paper, 12 by 18 inches. Rule on it two horizontal lines 12 inches apart.

One sheet of black construction paper. From this cut three strips 3 inches wide and 10 inches long.

Scissors and paste.

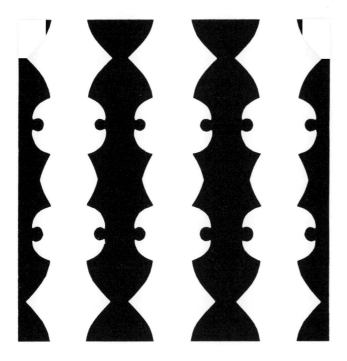

56 *Critique:* In this design, the black strips have been placed a trifle too far apart, thus making the white spaces rather heavy and cumbersome. The white area has the quality of thingness and reality for two reasons: it combines convex forms with the threat of a pincer-like movement.

Working Procedure

1. Fold the black strips vertically.
2. Cut the edges of the strips to form a pattern. Repeat this pattern on the other two strips. Make no design cuts along the fold or within the form. In designing the edge, try to establish a rhythmic pattern through repetition. Establish a beat that is either slow or fast, based on major and secondary accents. Your objective should be to devise a pattern that can be grasped by the eye as a satisfactory unit. If the pattern is intricate or confusing, the eye will tend to segregate sections into a different order and isolate them.
3. Cut one of the black strips in half down the center fold. These halves of the design will be used at either end of the arrangement to bracket your design.
4. Turn your white paper lengthwise and rule a very light pencil line one inch from the top as a guide for placing your strips evenly.

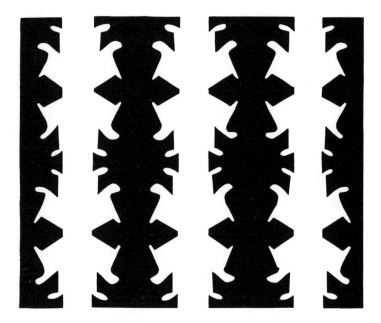

57 *Critique:* Here the black strip is seen first of all, consisting of a heavy cross-shaped motif, which, when repeated, creates a counter horizontal movement. The second repeated "open jaw" design has a very fine pattern. It is only after we have looked at the black and enjoyed it that we can see the white strip as a pattern.

5. Arrange two of the strips on either side of the center of the white paper in sufficient tension to form a negative shape.

6. Repeat this same negative shape through the same spacing on either side by proper placement of the split black form. The straight edges of the split shapes will serve as the side borders of the format.

7. Before pasting down the strips, put the problem on the floor so that, by seeing the design from a greater distance, you can make sure that there is sufficient tension between the black strips to create a good strong white shape. When you decide on the spacing between two center strips, try to repeat this space exactly. When the arrangement satisfies you, paste it down.

CRITIQUE: INTENSITY AND ILLUSION

When the student work from a whole class is arranged in rows before you, the first thing you might notice is that some of the black designs look darker than others. But then you will recall that all participants used the same black paper. In other

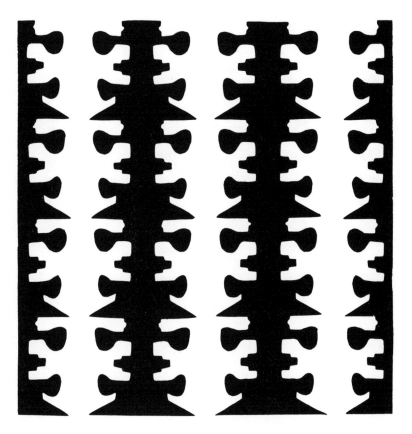

58 *Critique:* This is a very good exchange. The motif is complicated. We see the black first probably because of our interest in the stiff little nodules above and below the sharp points of the inverted triangles. However, the white design gives us the impression of a white stripe with a varied border of fringe.

cases you will notice grayish shadows or streaks that seem to run along the edges between the black and white. These deeper black and gray values are created by our vision when the detail of the edge of the design becomes intricate. Because the eye has difficulty in following such an edge, it will often blend and fuse intricacies into deeper black and make gray shadows.

After seeing these designs, perhaps we need to remind ourselves that all these patterns are created by black strips laid on white paper. All the work shown here that is successful demonstrates that the artist has ceased to discount the invisible as nonexistent and now gives it an equal reality with the positive.

59 *Critique:* Here the interest centers first on the horizontal fingers forming parallel strips through the center of the design. There is an even exchange between the black and white leaflike forms.

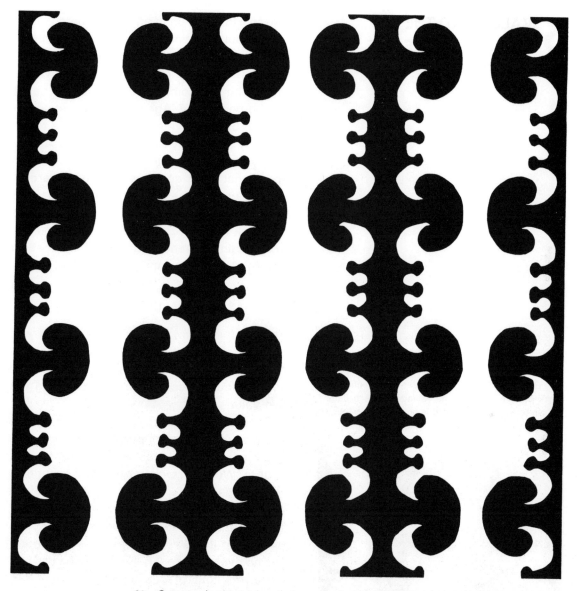

60 *Critique:* In this elaborate baroque design the black is seen first because of the opposition of the black kidney shapes. The design sets up a dual rhythm of a heavy and light pattern alternating between the bumper thrusts of the larger shapes and the fine repeated triple accents of the light secondary patterns. The white pattern, in contrast, is not a dual pattern, but a repetition of a single motif of a spouting white shape with hooks.

5 VALUE AND THE CONSTRUCTIVE USE OF TENSION

The fourth problem is again to create Notan from cut strips of paper, but this time in three values. In the previous assignments, a duality or dichotomy of attention was required—a consciousness of the positive and negative spaces at the same time. With this composition a certain "trichotomy" of attention will be necessary. Again the negative space must have entity quality, but your chief concern will be to make the black and the gray strips stay together as a unit. As in the previous problem, you are constructing two units of positive and negative space that must go forward or backward alternately at command. But this time the wider gray strip will be placed beneath the black strip with sufficient tension achieved in the design to interlock the two. Before considering the techniques required to maintain this tension, however, it is necessary to look more closely at ideas of contrast and value.

CONTRAST AND VALUE

Value refers to a range or scale of differences between dark and light. Contrast refers to the difference between values. In order to determine the contrast between two values, we usually find ourselves focusing on or along the edge where the two values meet.

Subconsciously we also use our tactile sense in determining contrast of value. As infants we explored our new world with our tactile sense—first with our tongue and later with our fingers. We still refer to a tactile sensation when we say that two values form a "sharp" contrast. For instance, maximum contrast in values is between black and white. Our tactile sense tells us that the edge where the black and white meet is so sharp that if it were a knife, we would not be able to run our thumb over it without being cut. If the gray used in this problem were very light, placed against the white background, the contrast would be much softer, producing a downy sort of edge.

Sharp contrasts in value hold our attention: they seem to be in sharp focus and lead us to examine them first. They focus near us—seem to come forward. Soft contrasts stay in repose or stay back. Often in painting when one area of a canvas

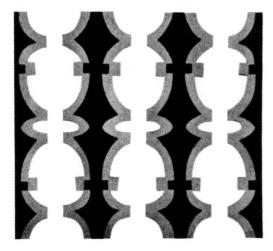

61 *Critique:* When the gray simply echoes the black pattern, it is just as willing to attach itself to the white as to the black. It is not fixed to either one by tension.

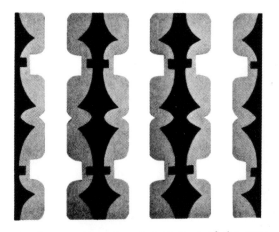

62 *Critique:* Here the straight lines of the gray oppose the points of the black strips, press in toward the cross-bar, and echo in reverse the concave space in the center. These tensions hold the black and the gray together. Then they were carefully spaced so that the white space stands out bold and simple.

seems to protrude, the artist will try changing the color, only to find that the problem remains because the contrast edge of the shape is so strong. *The eye always follows the edge of maximum contrast.* If the contrast is removed and the transition softened, the area will stay back.

One of the purposes of this fourth problem is to utilize this principle. When the black strip is placed on top of the gray, these two values must hold together as one unity in opposition to the white complement. The black and the gray must move together simultaneously either forward or back. We should be able to say, "Let the white come forward, let the black and gray stay back; let the black and gray come forward and the white stay back." And we should expect obedience. The gray should not be permitted to vacillate between accompanying either the black or the white (as it does in Figure 61). Moreover, in cutting your gray paper, do not cut into it so deeply that the black strip extends over the gray and touches the white. If this happens, the maximum contrast between the black and white will be produced, and the tension between the black and gray will be lost.

At this point you should check to see if your gray paper is of a middle neutral value with no strong affinity to either the black or the white.

INTERLOCKING THROUGH TENSION

The secret of uniting the black and gray is to set up tensions and oppositions between the shapes that will knit the two strips together. This rule is based on a universal principle: whenever we oppose anyone or anything, we create a tension that locks both in a relationship or a grapple.

Let us look first of all at Figure 61, where the gray echoes the edge of the black pattern. The gray form here repeats the black with no tension between them. The gray adheres either to the black or the white, creating a white design with a gray edge, or a black design with a gray edge.

In the second example (Fig. 62), however, the gray has intentionally been designed to set up tensions with the black. Here the gray stays with the black because tensions have been produced by oppositions.

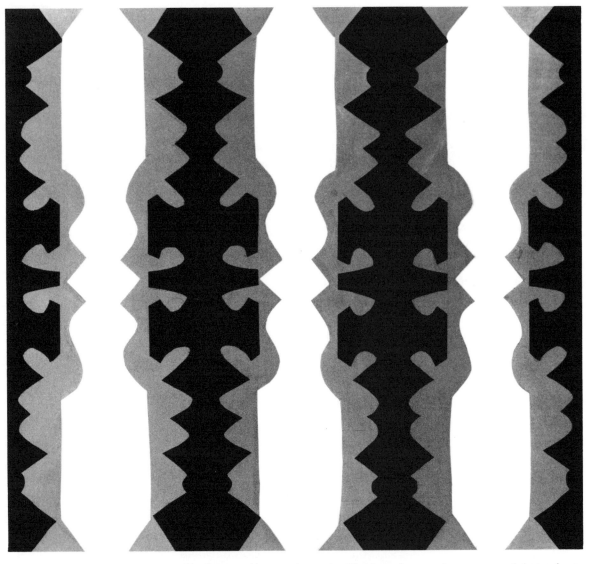

63 *Critique:* Here we have simplification of a complex passage of design by a long straight line. The long straight edge of the gray paper opposes the spears or points in the design: the double bracketing curves of the gray paper also oppose the central black design. It forms a strong white image because the gray is tightly amalgamated with the black.

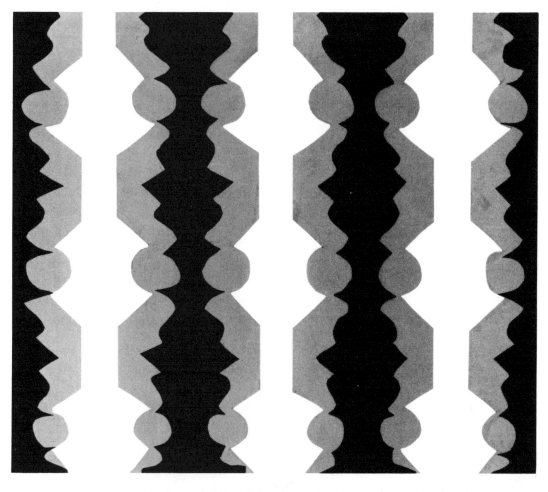

64 *Critique:* An example of a simple hexagonal gray shape bracketing a series of scallops topped by the concave black socket holding two gray spheres. The gray design simplifies the black form considerably, and also makes a strong white pattern.

PREDOMINANCE AND SUBORDINATION

The solution to this problem involves again the principles of predominance and subordination. Previously, we were seeking an exchange, or alternating predominance with *no* subordination. In this assignment, we will again seek an exchange, an alternation of reality between the positive and negative; but in order to achieve this duality, it will be necessary to interlock the gray, a third value, with one of the other forms. In this case the gray will be subordinated to the black, yet remain in sufficient tension with the black to create its own entity. The gray must not imitate the black, but must achieve its own reality of form.

In order to produce Notan in this composition, therefore, you will have to consider and balance three problems concurrently:

1. the design of a black form
2. the design of a gray form in tension with the black
3. the design of a negative white form that will alternate in an exchange with the gray-and-black combination.

Assignment Create Notan using strips in three values in which the gray and black remain together as a single unit.

Materials Three strips of black construction paper, 10 by 2 inches.
Three strips of neutral gray construction paper, 10 by 3 inches.
One sheet of white construction paper ruled with two horizontal lines 12 inches apart.
Scissors and paste.

Working Procedure

1. Cut the black design freely without thought of the gray.
2. Lay the strip of black design on top of the gray strip and study it. Analyze the edges of your shapes separately or in groups. What are they? What are their opposite shapes? How may they best be opposed? Can you simplify a com-

65 *Critique:* While the white design here is not very strong, the gray and black are definitely fixed together. In the center there is the suggestion of a horizontal stripe which gives the feeling of transparency where the gray paper brackets the black design.

plex passage in the black by the juxtaposition of a simpler one in the gray? Can you bracket the form? Do the black shapes thrust outwards? If so, can they best be opposed by a straight edge, a concave edge, or another form that makes an equal thrust back?

3. Are there any deep cuts in your gray strip that permit the black to touch the white?

4. Paste the black strip on the center of the gray strip. Then after cutting one strip down the folded center, arrange as in the last problem, separating the strips to create a strong white design.

5. Review, if necessary, that portion of the last chapter that concerns proper spacing and balance to produce negative design. Remember your object again is to create Notan.

66 *Critique:* Here you see the white design first. In this composition the gray paper has been cut to thrust out into the white. At the same time it seems to pull the white back in, making a very lovely pattern.

6 THE ELEMENTS OF DESIGN

Up to this point we have been concerned not only with Notan but also with many of the most basic elements of design. Like Notan, all of these elements have their basis in universal laws. This chapter will bring together other basic elements of design in one interpretation of their origin and relationships as seen through symbols.

Let us begin with design's simplest component, the line. The line begins with a point. Its movement can proceed from right to left, or left to right, from top to bottom, or bottom to top. Various civilizations have based their writing and reading on their different choices of these directions of movement. Movement is line, or line equals movement. Note, too, that as soon as we draw such a line, we have the minus sign.

Now suppose we want to stop this movement; we want it to become fixed. We can accomplish this by drawing a perpendicular line of equal length through the first line (Fig. 67). By doing this, we obtain the scientific symbol for plus or positive. Philosophically, it represents the changeless. It also serves, as we have discovered, as a representation of *opposition*—and opposition is a basic principle of design.

The second element, *repetition,* may be illustrated by rotating the plus sign a quarter turn on its axis. This, superimposed on the plus sign, gives us a repetition of lines of equal length. The result is a symbol of radiation (Fig. 68) where the lines are moving outward from one fixed center. In depictions of the sun (Fig. 69) we use this symbol: repeated lines of equal length radiating from a central point and forming a circle. The lines of the symbol of radiation can also be seen as moving inward, suggesting the polar opposite of radiation, or absorption. This exchange between the radiating, or going out, and the absorbing, or pulling in, is a fundamental process in nature. This dynamic interaction is present in all living things.

A third element of design is *subordination.* In Figure 70 we see that the plus can be changed to the cross by subordinating what was the equal opposition of lines. Both in its length and placement, the horizontal line is subordinated to the perpendicular.

67 Opposition in its simplest form is seen as a cross or a plus sign, a symbol of the fixed and symmetrical.

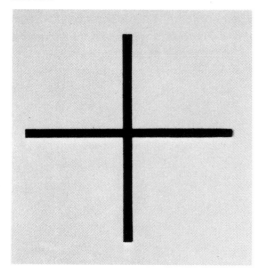

Subordination is related to repetition. In its simplest form it may be seen as a circle around a dot or a small square within a larger square. Figure 71 shows this form of subordination with repetition. The small square repeats the larger black square, but is still subordinated to it because of its size. Figure 72 combines opposition and subordination in the size and arrangement of two squares. The smaller square, instead of repeating the larger, creates tension by opposing the straight lines of the larger square with its points.

Subordination appears in nature in the target pattern made by a pebble dropped in water, but in this instance we find a *subordinated sequence* of forms, each form being larger or smaller than its successor. This concentric series of subordinations implies the idea of growth, but it is the spiral which best symbolizes the growth process. The spiral moves continuously from the center outward, and from something small such as our planet, widens to include the solar system, galaxies, and nebulae.

These, then, are some of the most basic elements of design: the movements and shapes of the negative, the positive, radiation, the circle, and the spiral. They may be related or arranged in opposition, repetition, subordination, contraction, or expansion. These shapes, movements, and arrangements are basic to every form in nature: one may see them all in the structure of the simplest flower. And in order to design well, we must include these elements in our forms just as nature does.

68 When the plus sign and the X or multiplication sign are superimposed, we have the basic symbol for radiation.

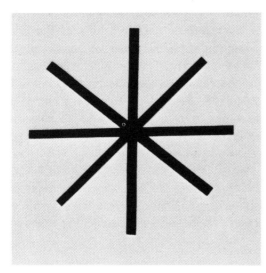

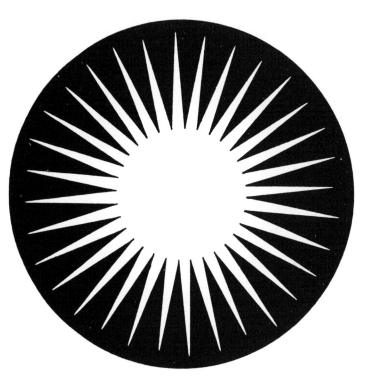

69 When the center ceases to be a point and the rays are multiplied, we have the symbol for the sun.

70 The symbol for subordination is the cross when the horizontal arm is shorter than the vertical.

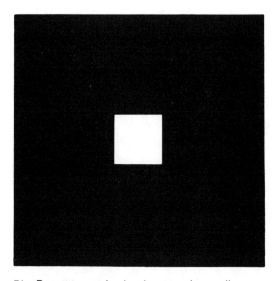

71 Repetition and subordination: the small square repeats in miniature the large square; at the same time, because of its smallness, it is said to be subordinate to the large square.

72 Subordination with opposition: here the small square is placed so that its corners oppose the sides of the large square.

7 A COMPARTMENTED DESIGN
Part I: Problem Using Rectangles

This is the first part of a two-part problem in composition. The aesthetic quality of your work will depend entirely on your personal selection of sizes, proportions, shapes, and the way you distribute your values, but there are four definite restrictions:

1. There should be no diagonals or overlapping of the edges that would destroy the rectangular shapes.

2. No two of the same values should adjoin and thus create a shape other than the rectangular.

3. No two of the rectangles should be the same size, but they may be very thin or very wide or extend across the width of the composition.

4. Since you are limited to three values in five areas, you will find just three distributions of value possible:

2 white	2 black	1 gray
2 white	1 black	2 gray
1 white	2 black	2 gray

This is not as easy as it sounds. The next time you see a Mondrian painting you will appreciate the subtle variations of size and the delicacy of balance he employed.

In considering the variety of sizes to use, think back to the first problem. The most pleasant composition, you will remember, selected and arranged a very large shape, a very small shape, and three sizes in between. What you want to do now is to avoid an unconsidered, unhurried selection that is "average." Instead, as in all artistic development, you must remain painfully conscious until your intention and your execution can become one. Only in this struggle to put intention and execution together does the artist find his development.

When you study Figure 73, you will find that the eye moves first to the black shapes whose edges are against the white shapes, and then to the gray. This is because the eye always goes first to the sharpest contrast—in this case to the contrast of the black edge against the white. As you will remember from your last problem, the gray forms a softer edge or contrast after the sharp contrast of black and white. Before you paste down your arrangement, see how the point of interest can be

73 *Critique:* In this arrangement of five areas, the mistake was made of letting two white areas come together, with the result that the two areas register as one white area with an unpleasant extension, which is spoken of as a "dog leg."

74 *Critique:* The eye starts with the strongest contrast in value, which is between the black and white areas. It travels down to where the white touches the black square and then sweeps around the grays. We sense forced eye travel as "interest" because our attention is held for a while.

moved by changing the arrangement of the black, white, and gray so that the gray falls against the white and the black against the gray, etc.

Problem Divide the format into five areas, no two of which are alike. Use horizontal and perpendicular lines only—no triangles or curves are allowed. Distribute the black, white, and gray so that no two rectangles of the same value are juxtaposed.

Materials White construction paper, 12 by 18 inches, with a ruled 10 by 12 inch format.

Black and gray construction paper to be cut in rectangles.

Scissors and paste.

Working Procedure

1. Make small sketches of your design on newsprint first, then decide what their dimensions will have to be in inches.

2. Cut the rectangles to size from the construction paper and paste them down. For the white rectangles, just permit the white paper of the format to show through. Rule the edge if it borders on the format.

Part II: Tool Theme and Variations

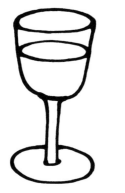

75 A wine glass in ordinary perspective describing volume in space.

76 The same wine glass, but now the salient characteristics of each part are clearly described. What is known about the glass, rather than how it looks in space, is the main concern here.

Your objective in this problem will be to create Notan by modifying the design of a tool to fit four of the spaces in the composition just completed for Part I.

REPRESENTATION IN ART

All artistic representation depends on visual conventions, which vary with different periods in history and with different people. They all seek to show aspects either of the visual world or of the interior world of ideas and imagination.

Perspective is one of these conventions. If we were to draw a wine glass, we would start with an ellipse, then continue drawing each side, followed by the stem, and finally represent the foot with another ellipse (Fig. 75). These ellipses are our way of stating that the wine glass occupies space. They are our way of describing its shape, because our sense of reality depends upon the plastic quality of form, or the illusion of form in space. The medieval artist would have started this way: the glass is round, so he would have drawn a circle. The sides are parallel and straight, so two straight lines attached to the circle would represent the sides. It has a rounded base: he would have drawn an inverted arc. It stands on a stem which is a cylinder of glass: again two straight lines would serve. It has a round foot, which another circle could represent. And, finally, it is half filled with wine, so a straight line would be drawn to represent that level (Fig. 76).

Now this drawing should begin to look strangely familiar, for at the beginning of the twentieth century when artists such as Picasso and Braque began to examine *how* they had been taught to see and describe their world, they went back to some of these earlier methods of seeing and incorporated this approach in their paintings.

But suppose all that we wanted to convey was the idea of a glass, as contrasted to a cup, for instance. Then all we would have to do would be to draw the silhouette of a wine glass (Fig. 77).

Now all three of these drawings can be labeled "wine glass."

They are all symbols of a mental image. In one, the idea of space is present, in the next all the elements are described, and the third is a symbol in its simplest visual form.

No matter what convention of representation the artist uses, all elements in his work must be given equal consideration. As students we have the tendency to consider one part of our composition more "real" or important or meaningful than another, especially if we are working in a representational manner. We consider the "thing" we are painting more important than what is around it or the background against which it is seen. The function of design, however, is to integrate both these elements so that they form an artistic whole or single unit. This is our objective in the tool problem.

The tool is our theme, and we will vary this theme in such a way that it and the space around it function as a single unit of design. In order to do this we will deliberately distort the tool.

WHAT IS DISTORTION?

Most of us resist any distortion of a recognizable image. Yet the artist must distort or modify form, not only in order to express his ideas, but to preserve the unity of the picture plane. All spaces must be designed so as to maintain an exchange of importance with one another. When the design is successful, nothing can be added, nothing can be taken away. All relationships must be established and united through this exchange of equality.

The privilege and necessity of design to distort for the sake of unity has always been an instinctive device in the arts of primitive cultures. Look again at the example of Northwest Indian art (Fig. 6) discussed in the first chapter: here subject matter finds perfect unity with form and function.

Let us go back now for a moment to the first problem in this book. When we were composing this assignment, we concentrated only on the reality of the black paper, without considering the negative spaces or the unity of the whole. Then when we regarded the black spaces as holes, all reality was subtracted from the black paper, and the white areas became very

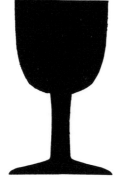

77 The silhouette of the wine glass is concerned entirely with shape and proportion.

real. Still this was not the solution: either way only one element was given importance. When, however, we saw the black as rocks and the white as water, interacting with one another, one plane of reality was formed. The negative space had attached itself to the positive: it could no longer appear as depth or run behind the form. All parts of the design were equally important and on the same plane.

In that assignment, however, our shapes and spaces were nonrepresentational. Suppose that our black shapes had been objects with more complex form and that, in order to make the negative spaces equal in reality, we would have had to distort and change our positive shapes. Here our accustomed orientation of reality would conflict with artistic necessity. Distortion for distortion's sake would be just that. But distortion in order to let "no-thing," the background, have reality, "thing-ness," produces harmony and an exchange between the forms.

When we begin to work in art, we find that we do not mind distorting some kinds of things that can actually grow in a deformed way—trees, for instance. But what about a chair or a chimney? Man-made structures or functional objects are the most difficult for us to distort. Here our resistance is greatest, for objects designed for a utilitarian purpose must maintain their shapes and proportions in order to serve their functions. For just this reason, therefore, the tool—the most familiar and functional of objects—has been chosen as the subject for our next problem.

The tool was also selected because of its familiarity to our tactile sense, a characteristic that will run with, rather than against, the psychological grain. The objects we draw best are those most familiar to our hands. A poultry-raiser, for instance, who handles turkeys every day, would have the best kind of tactile familiarity to translate their structure into line. The animal drawings and sculpture of the Eskimo hunters and fishermen record their sensitivity to their tactile experiences. Their hands speak of their familiarity with the weight, contour, and structure of the bodies of animals, both alive and dead.

Your objective now is to create Notan by modifying the

78 The tool used here was a can opener with a hook for removing bottle caps (upper right-hand corner). The hook was seen as the most dynamic part of the tool and dramatized by accenting the pinching, gripping aspects.

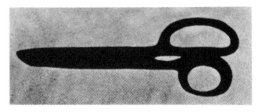

79 This is a factual silhouette of a pair of scissors. The rectangle enclosing them is too large to fix them in space, i.e., there is no tension and hence no Notan.

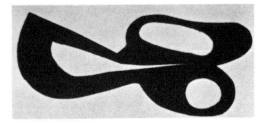

80 Variation No. 1. The ability to cut has been subtracted from the scissors, but places for thumb and fingers are still usable. The form is well placed in the rectangle.

81 Variation No. 2. The form here is now abstract. The interest is centered in the spaces which are balanced asymmetrically.

design of the tool to fit four of the spaces in the Mondrian-like composition you completed in Part I. In order to achieve this purpose, however, you will need to wrench your mind from the horns of reality and train yourself to think of the tool in terms of new forms. The following suggestions will help you to do this:

Begin by pretending that the tool is made of rubber—that you can stretch it, twist it, or mash it at will.

Pretend that the tool, like a pair of scissors (Fig. 79), no longer has a utilitarian function; that the curved handles no longer need to fit the thumb and fingers; or that the handle of a hammer need not be long or wide enough for the grasp of the hand.

Beware also of the tyranny of proportion. That which is functionally subordinate to the whole of the object may be made the most important. If you are working with a fork, there is no reason to keep the tines subordinate to all other parts. The thickness or thinness of any part of your tool is no longer relevant (Fig. 80).

Avoid movements so complex that their contour is lost by the eye. Watch your handwriting habits (such as the S curve), and do not transfer them automatically into your drawing.

Do not forget the importance of repetition in design: it is always the first thing to catch our eye. Recurrence makes us feel reassured.

Decoration of form adds excitement but should always remain secondary to the design.

Watch the sequence of your whole composition consisting of the five tools in the five rectangles. A sequence of distortion is desirable: from the only slightly altered to the completely abstract.

Problem Draw and cut one silhouette reproduction of the selected tool to fit one of the spaces in your black, white, and gray composition. In the other four spaces, modify the tool in design to fit these spaces and create Notan. The values of the tools and rectangles should *contrast*.

Materials Your completed compartmented problem from Part I in black, white, and gray.

One tool selected from your kitchen drawer or tool chest. Suggestions: a spatula, fork, slotted spoon, beer can opener, key, scissors, clothespin, safety pin, wrench, hammer, monkey wrench.

Several sheets of newsprint for sketching.

Working Procedure

1. Make some sketches of your tool, simplifying it to a two-dimensional silhouette of its form.

2. Study your black, white, and gray composition; then look at your silhouette. What four modifications of this form are possible to fit them into four of your rectangles?

3. Look at the rectangles as though they were boxes, and select one that you think would hold the representational silhouette of the tool in its natural proportions comfortably. Only, in this case, it need not be a tight fit; it can rattle a little in its box.

4. Outline the dimensions of your rectangles on scratch paper, and play with "distortions" of your tool within these rectangles until they not only fit into the rectangles but also create Notan as in Figure 81. Remember that the negative spaces should be neither too large nor too small to exist as entities reacting with the tool forms. If you forget these negative space restrictions and merely concentrate on your design of the tool, then all of your work in this assignment will be to no avail.

5. When you are satisfied with the design of your modified shapes, cut them from the scratch paper and use them as patterns on top of your construction paper. You will, of course, choose values that contrast the tool with the value of its assigned rectangle.

6. Place and paste the construction-paper tool forms into their assigned rectangles in the black, white, and gray composition.

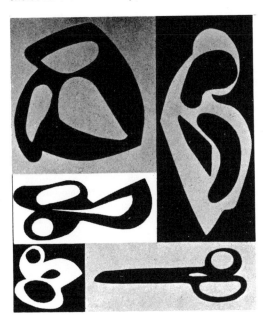

82 *Critique:* Our theme here is a pair of scissors. The variations concentrate on manipulating and varying the interior openings of the scissors. The Notan achieved is good and the placement of the black tool on the white square was a dramatic choice for the entire composition.

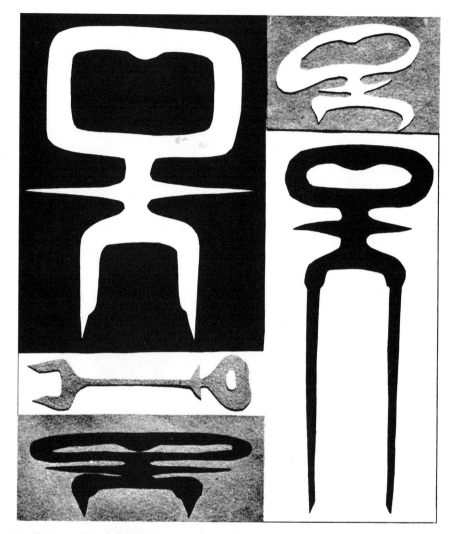

83 *Critique:* This composition is only moderately successful. The tool used is a carving fork represented in the lower right-hand corner. The student modified the handhold of the fork, but was never able to make any radical change in the sharp prongs. However, this work is satisfying aesthetically because of the balance of darks and the diagonal relationships of the gray squares.

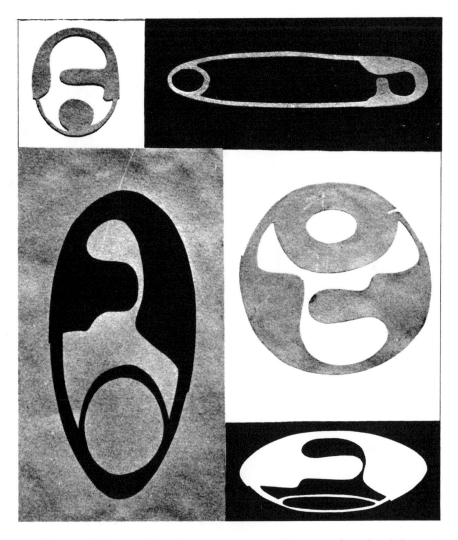

84 *Critique:* Safety pin. Here there is a sequence of distortion from the slight one in the lower left to the very abstract one in the middle right. Nevertheless, the student concentrated so thoroughly on the tool design that he neglected to watch the negative spaces around the tool, which lack interest. This is especially true in the upper left-hand corner. In the lower right-hand corner the spaces are more dynamic.

85 *Critique:* The tool chosen here is an attachment for a meat grinder (upper left-hand corner). One of the characteristics preserved and exaggerated to become a dynamic part of the designs was the small notch at the top of the blade. The units of design themselves have an organic quality which is very pleasing. But all designs, except for the one in the upper right-hand corner, are crowded and a little too large for the space they occupy. However, the over-all effect is very satisfying.

86 Pictograph, Alamos, Sonora, Mexico by Bill Brewer. Collage on canvas with string. A fine example of asymmetrical balance. The sun symbol dominates: the cross and the arch symbolize the town of Alamos. Used with the permission of the artist.

87 Rubbing of New England Gravestone: Mary Ann (from *Early New England Gravestone Rubbings* by Edmund V. Gillon, Jr., Dover Publications, Inc., New York, 1966. Reprinted through permission of the publisher.) At first the tips of the plants seem to support the arches above them; then suddenly we cease to see the leaves, and see only the lily shapes of white pushing upward.

88 Rubbing of New England Gravestone: Almira Graves (from *Early New England Gravestone Rubbings* by Edmund V. Gillon, Jr., Dover Publications, Inc., New York, 1966. Reprinted through permission of the publisher.) The gaiety of the Notan exchange in the designs on either side of the urn negates the solemnity of its purpose.

89 Cover design for Religious Art of Northern California catalog, Osborn/Woods, 1966. Black on brown paper. The variety of size and shape of the negative spaces gives richness and interest to this collage.

Barbara Stauffacher

90 Monthly Calendar design for April, 1967, by Barbara Stauffacher, graphic designer for the San Francisco Museum of Art, California. A very effective rhythmic reversal pattern of the name Klee.

91 Lettering (actual size) from psychedelic poster designed by Victor Moscoso, produced by Family Dog Productions, San Francisco, California. This lettering has been deliberately designed so that the negative spaces are first seen as positive decorative shapes. In black and white reproduction it is easier to ignore the negative spaces in order to see the positive letters. In the full-color original, the red letters vibrate with the green negative spaces, attracting the eye but making it very difficult to read the message.

The Museum of Modern Art

92 Museum of Modern Art shopping bag. This simple dark-light design so often used by primitive weavers loses none of its effectiveness when translated into printer's ink on a paper bag.

8 NOTAN AND THE INNOCENT EYE

In the first part of this book Notan as a concept was explained through the symbol of the Yang and the Yin. Our understanding of Notan, however, does not have to remain on this rather complex philosophical level. More important, the search for Notan should force us into a more creative observation of our surroundings and revive in us a sense of the wonder of life.

Much of this discovery will involve the recovery of something that we all once had in childhood. When we were very young, we were all artists. We all came into this world with the doors of perception wide open. Everything was a delightful surprise. Everything, at first, required the slow, loving touch of our tongues and our hands. Long before we could speak we knew the comfort of our mother's warm body, the delightful feel of a furry toy. Smooth and rough surfaces, things cold and hot surprised and enchanted us. Touch by touch we built up our store of tactile impressions, keenly sensed in minute detail.

Later on, this tactile sensing was transferred to our eyes, and we were able to "feel" though the sense of vision things beyond the grasp of our hands. This kind of seeing was not the rapid sophisticated eye sweep of the well-informed. This kind of seeing was a slow, uncritical examination in depth. The more we looked, the more lovely, surprising things appeared, until we were pervaded by that wordless thrill which is the sense of wonder.

None of us have lost our store of tactile memories. Nor have we lost our sense of wonder. All that has happened is that we have substituted identifying and labeling, which can be done very rapidly, for the tactile sort of feel-seeing which requires much more time and concentration. For example, if you were asked to look at the edge of your desk and estimate its length, it would take you only a few seconds to flick your eyes back and forth and say it is so many inches long. But suppose you were asked to run the tip of your finger along the edge of the desk and count every tiny nick? You would press your finger along the edge and move it very, very slowly, and your eye would move no faster than your finger. This slow, concentrated way of feeling and seeing is the first step towards regaining our sense of wonder.

93 Carved and dyed calabash. Oyo, Western Nigeria.

94 Animal mask. Black paper cutout by student.

95 Section of wedding gift tapa cloth. The word *Tagi*, meaning "to cry," was the bride's name. Made around 1920 in Tau, Manu'a, American Samoa.

There was a time when man moved no faster than his feet or the feet of some animal that could carry him. During that period the artistic or creative spirit seemed to have free expression. Today, in order to be creative and yet move smoothly and efficiently through our fast-paced world, we must be able to function on two different speed levels. The mistake we have made, often with tragic results, is to try to do *all* our living at the speed our machines have imposed upon us.

In order to live at this speed we must scan the surface of things, pick out salient aspects, disregard secondary features; and there is certainly nothing wrong in this if we are driving on a busy freeway. But when we allow this pressure to invade every aspect of our life, we begin to "lose touch," to have a feeling that we are missing something, and we are hungry for we don't know what. When that happens, we have begun to suffer from aesthetic malnutrition. Fortunately, the cure for this condition is very pleasant, and although it takes a little self-discipline at the beginning, the results are worth the effort.

By the time we finished the third Notan problem we should have noticed how Notan operates in the allied arts. In architecture we are suddenly aware of the spaces between the windows, at the ballet we notice how the spaces between the dancers open and close, and in music we realize that rhythm is made by the shapes of silence between the notes.

Everywhere we look we see the principle of Notan in action. Trees are not silhouetted against blank air, but hold blue spangles between their leaves while branches frame living shapes of sky. Space seems to be pulled between the leaves of a fern. We delight in the openings between the petals of a flower or the spokes of a wheel. This endless exchange between form and space excites us. Once more we feel in touch with our world; our aesthetic sense is being fed and we are comforted.

In the very last problem we were asked to modify a familiar tool until it interacted with the space around it as an abstract design. When we tried to do this, we probably found that if we thought of the tool as an unfamiliar thing whose use we could not imagine, we would be free to change its form and destroy its function. This is not an easy thing to do. As soon as we try,

96 Aderi cloth. Nigerian stenciled starch resist and indigo dye on muslin. From Abeokuta, Western Nigeria.

97 Handsome dark-light pattern of alternating suns and flowers.

a busy little voice starts to chatter: "You know what this is... it's a fork. You use it this way..." and on and on. We must silence this know-it-all part of us if we would break through the concretion of facts we have collected to achieve the innocence of vision that we had as children and that we must have as artists.

Since we are no longer children, this innocence of vision is not based on ignorance, but rather on the ability to discard incidental bits of information until we lay bare the basic generating principle. And this is where self-discipline is necessary. We may have been taught that butterflies are lovely and toads are ugly, so we admire the butterfly and shrink away from the toad without really examining it to find out if what we had been taught is true. Or we are taught that flowers are good and weeds are bad, so we pull up the latter without a glance.

To the artist's eye there is no good or bad. There is just the inappropriate. In the garden weeds are not appropriate, but in the vacant lot they offer a world of enchantment. And after we have learned to see the beauty in weeds, even though we have to pull them out of the garden, we can first admire their design.

When no preconceived ideas keep us from looking and we take all the time we need to really "feel" what we see—when we are able to do that—that universe opens up and we catch our breath in awe at the incredible complexity of design in the humblest things. It is only when this happens that we regain our sense of wonder.

ACKNOWLEDGMENTS

HISTORY OF NOTAN STUDY

The term Notan was probably first introduced to the U.S. in the 1890's by the Oriental art scholar Ernest F. Fenollosa. His colleague, Arthur Wesley Dow, was the first to apply Notan to Western art design in his book, *Composition* (1899).

In the 1920's, on the West Coast, Rudolph Schaeffer first taught this principle of design at the California School of Fine Arts, and it was there that Dorr Bothwell came under his influence. Schaeffer was familiar with Dow's work but devised his own methods and problems for teaching Notan—or rather of enabling his students to perceive Notan so that they could learn to use it.

Dorr Bothwell was first attracted to Schaeffer's classes because of the extraordinary brilliance and range of his students' work in color. In an age of neutralized tones and ubiquitous browns, Schaeffer was insisting that his students work with hues in full intensity and based his teaching of color on scientific findings concerning color as light rather than on color systems and theories (harmonic triads, etc.). Moreover, he taught the application of the principle of Notan in black and white as well as in color—and it was precisely the understanding and the use of Notan in the color designs of his students that made the achievement of their harmonies possible. (In this book only the dark/light Notan has been examined in problems involving black and white; the problems are far more complex when carried over into color.)

For Dorr Bothwell, in her painting, her life, and her teaching, the concept and application of Notan has been one of deep and lasting significance, and she has continued to explore its implications throughout her career. It has indeed become a lifetime study.

98 Electric plugs and cords seen as flower forms and arranged to produce Notan.

99 Festival design. The central motif is the whirling swastika sometimes called the "wheel of heaven." Around it are the four cardinal points of direction which in turn symbolize the four elements of air, fire, earth, and water.

FURTHER ACKNOWLEDGMENTS

This book was made possible first of all by the students of the California School of Fine Arts, the San Francisco Art Institute, and the Mendocino Art Center. Their works serve as illustrations throughout this volume.

To Fred Rimbach and Willis Foote we are greatly indebted for all the photography of student compositions, of Miss Bothwell's paintings, and of the examples of Notan from her own collection.

Our thanks also go to Peter Green, author of *New Creative Printmaking* (B. T. Batsford, Limited, London, and Watson-Guptill Publications, New York) for permission to adapt for our own purposes (in our Chapter 3) one of his print problems appearing in his book on page 97.

We are also grateful to Houghton Mifflin Company who consented to let us publish Arthur Waley's fine translation of the poem from *The Way and Its Power, A Study of the Tao Ti Ching and Its Place in Chinese Thought*, 1935.

Finally, we are most thankful to the anonymous folk artists whose contributions to this book cannot be acknowledged.